Forty Whispers

Andrea Guzzetta
and
Alisa Secor

A Note From the Artist

Alise and I first met at the Milwaukee Institute of Art and Design in 2008. My first memory of her is doing a project where she wrote one haiku a day for a month, then placed each tiny poem in a tiny hand-made book. I instantly fell in love with this project. Anyone who knows me knows that I love tiny things: I have a tiny dog, eat tiny desserts, and date men almost exclusively under 5'8" (call me Bruno Mars!).

Last year, I discovered how much I loved making tiny paintings. Both series included in this book contain oil paintings that measure only 6" x6".

Concurrently, Alise was producing more tiny poetry, which I marveled at on Instagram. Her work resonates with me because they are poignant observations of the same themes I explore in my paintings: love, death, fantasy, wonder, finding your own power, and abolishing fear. Each of her poems reads like a tiny confession, scrawled into a diary or whispered into the ear of a lover. In this book, we have both exposed the most vulnerable parts of ourselves, our secret interior thoughts. We hope you enjoy it.

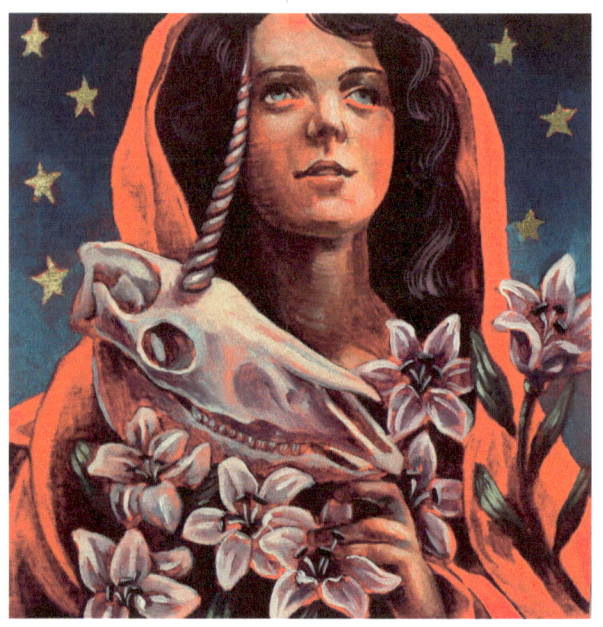

Hold on to Some Type of Innocence

Once upon a time
a girl dared to dream
big dreams
Ceaseless ambition

A moment of hope
I thought I felt
your light touch
it was just the wind

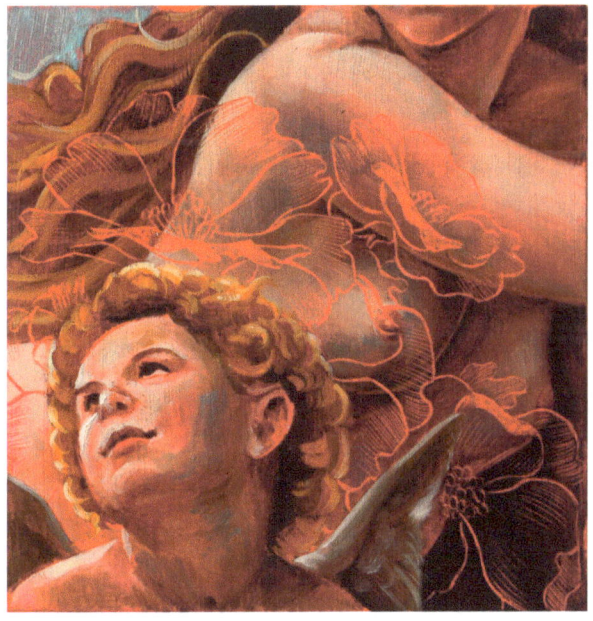

Pubescent Daydream

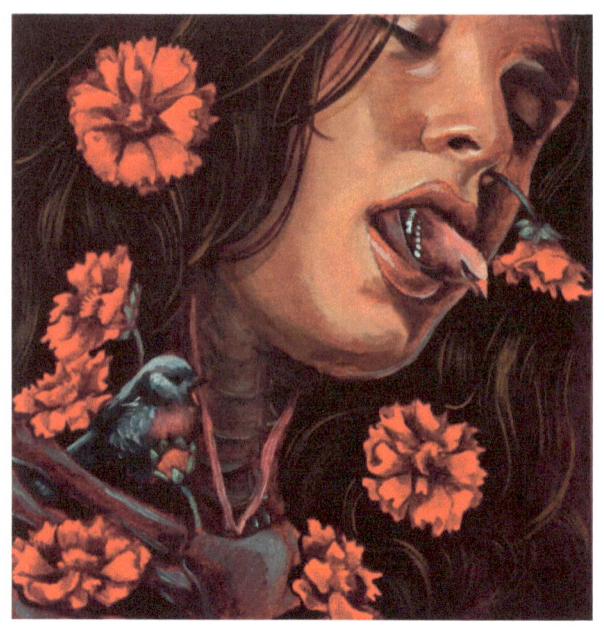

Lovesong: The Killing Stroke

those three
precious words
I let them melt
 on my tongue
and they went silent

*She's a perfect storm —
a fearsome thing
to behold
beautiful and wild*

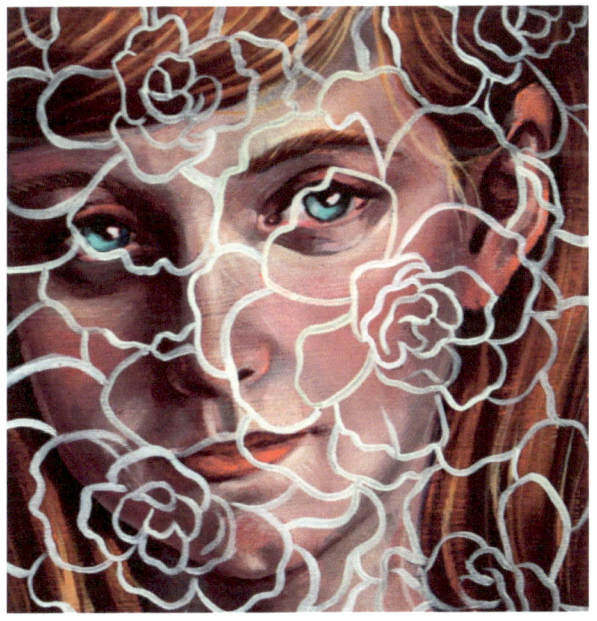

Veiled Woman

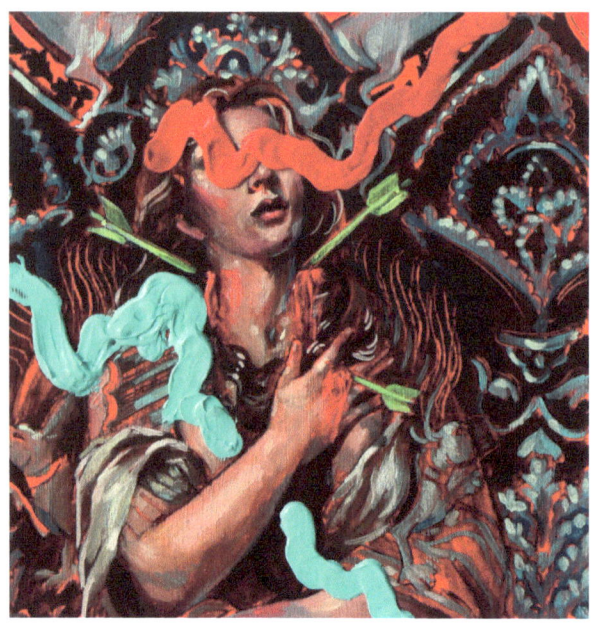

Sacrificial Saint

Poor transient hearts
they want everything
at once
doomed by desire

Believe in forever
old ties are hard to sever
truth binds together

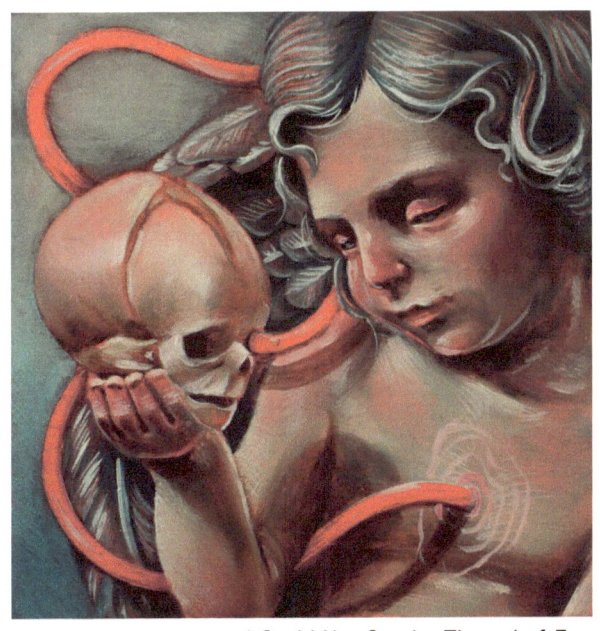

I Could Not Cut the Thread of Fate

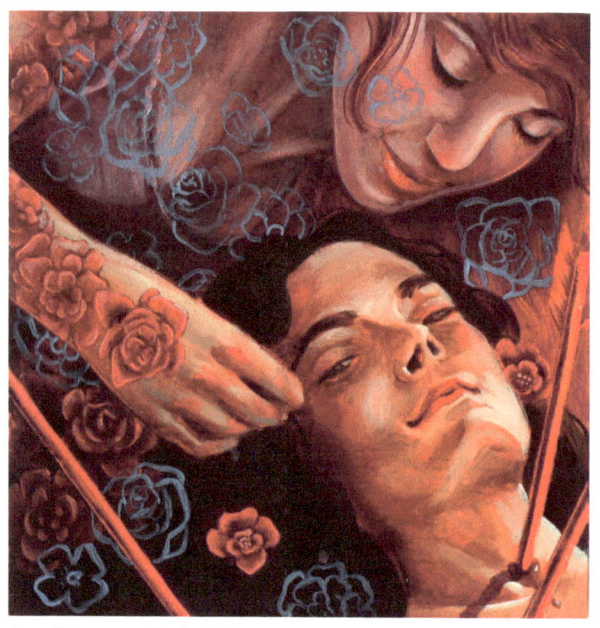

Lay Me on a Bed of Roses

Home away from home
I have been many places
no place like your arms

*I live in daydreams
I pass through Reality
like a phantom girl*

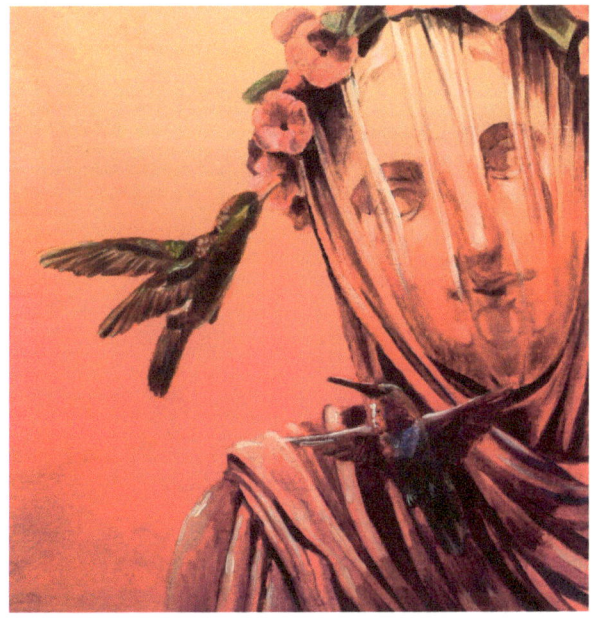

Take Me to the Spirit Land

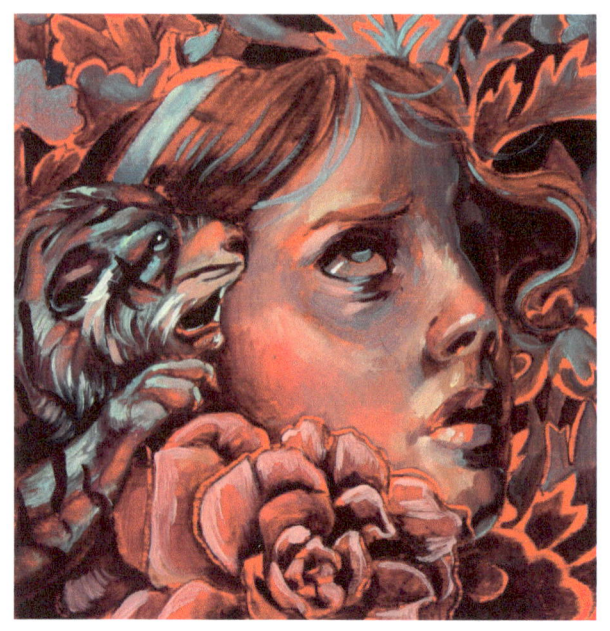

Siren Song

It's never been clear
how you infiltrated me
if only you knew

I can't sweat you out
his touch can't
cover you up
go haunt someone else

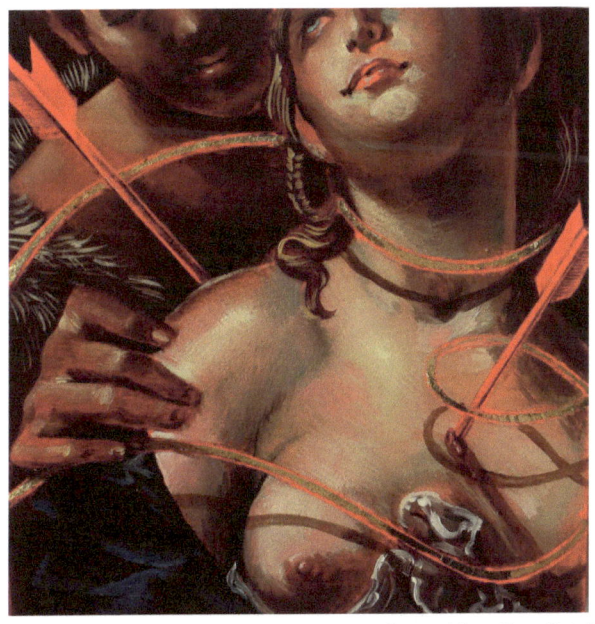

Something Sacrificial

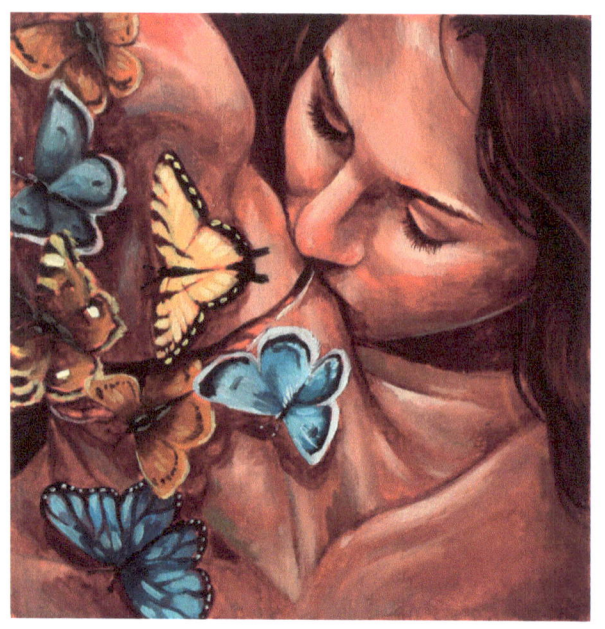

You Used to Give Me Butterflies

We were so careful
yet somehow
they still got in
Sneaky butterflies

*I am the forest
outstretching my
arms to you
absorbing your warmth*

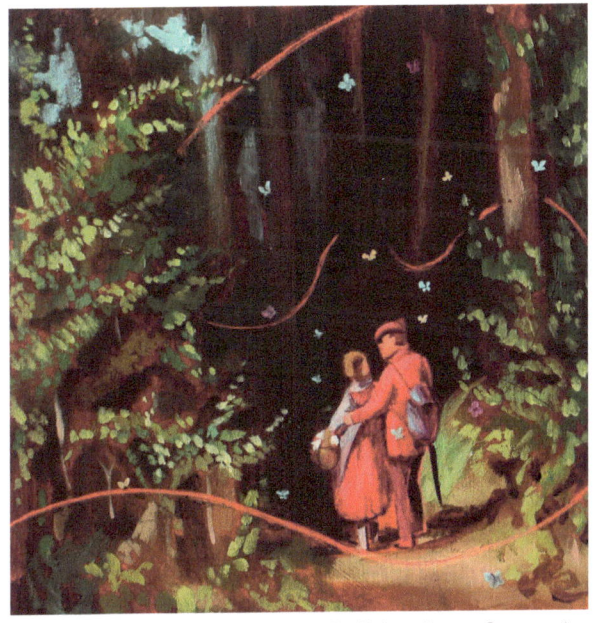

We Felt a Deep Connection

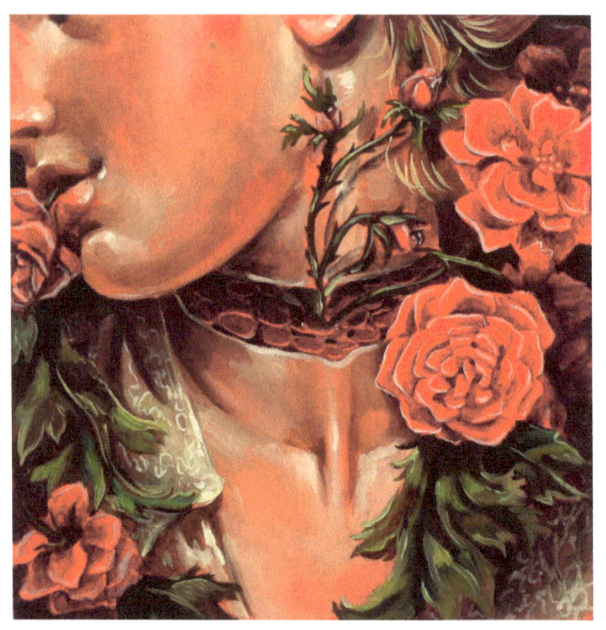

Something Grew Within Me

Life gushed from her wounds
She mourned her unlived future
She begged for saving

Air to my embers
Spontaneous combustion
from the outside in

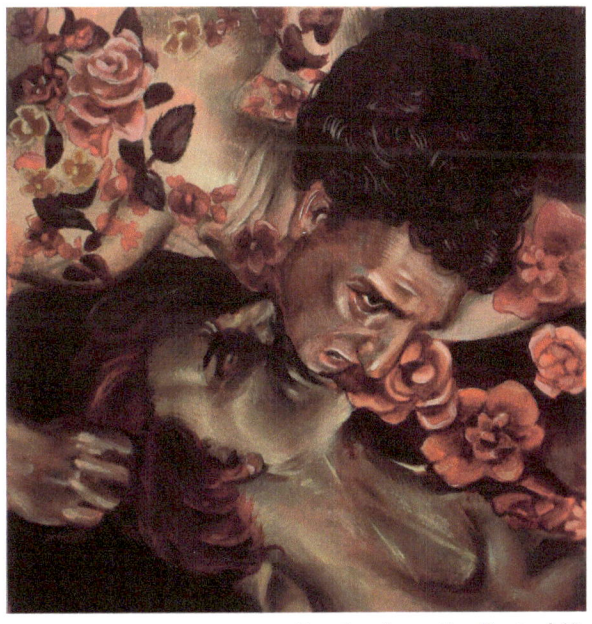

You Ate Away the Best of Me

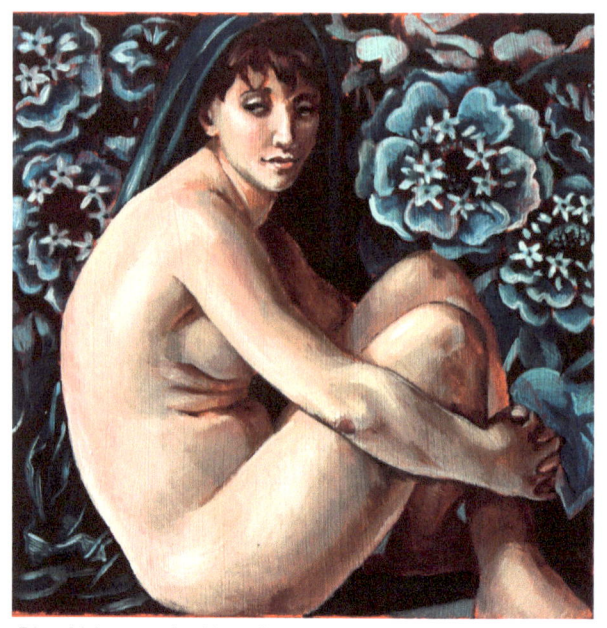

Blue Velvet and a Hopeful Virgin

Wishing you were here
I even miss your shadow
my hands long for yours

*Beautiful chaos
a mental kaleidoscope
searching for
some light*

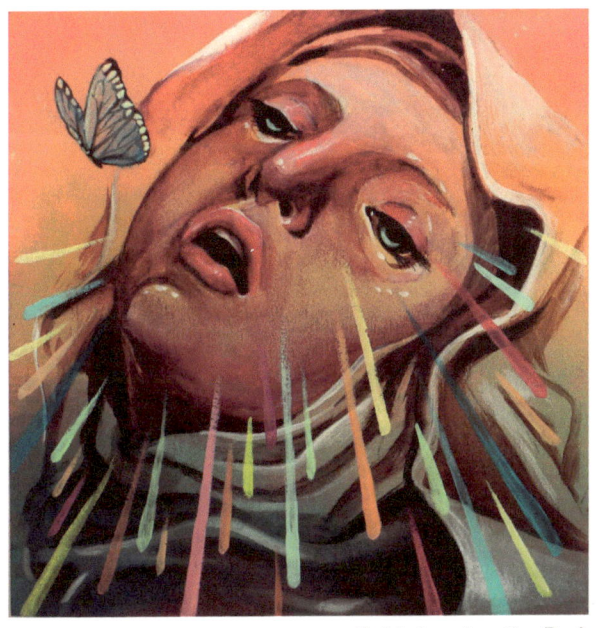

Spirit Leaving the Body

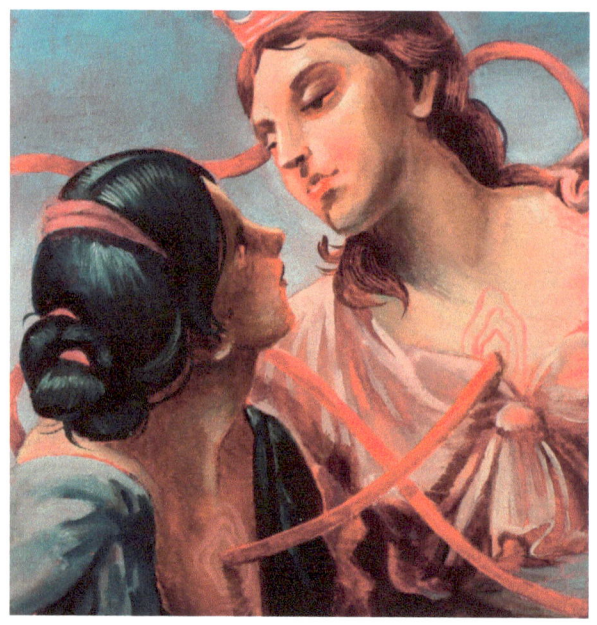

And Then We Were Lovers

If I do one thing
I hope it's make you
happy
brilliantly happy

*It's time for a risk
uncharted territory
take my hand. Let's go*

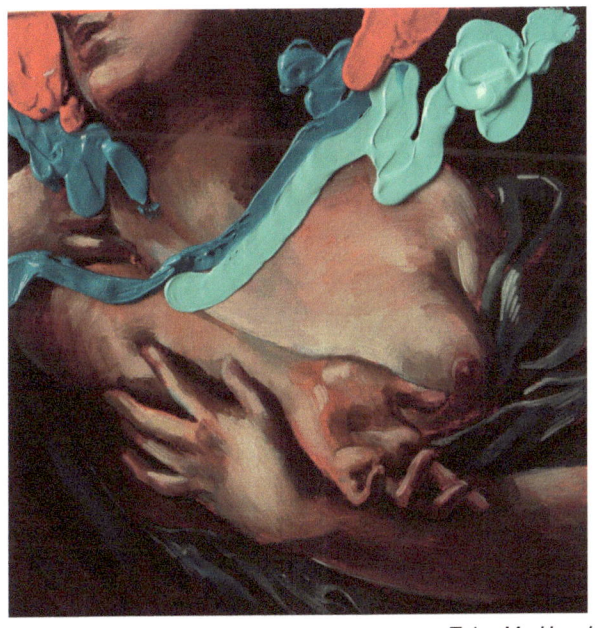

Take My Hand

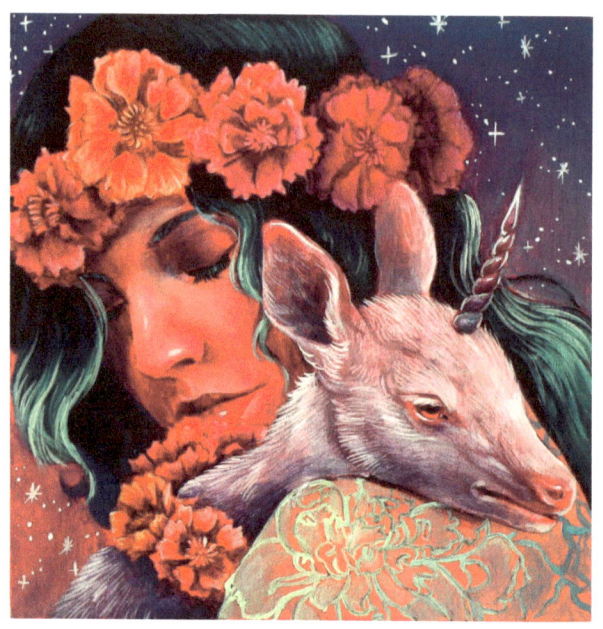

The Last

A wild desire
to be drenched
in fantasy
'til it becomes me

Sometimes when you're lost and your heart has no compass floating beats searching.

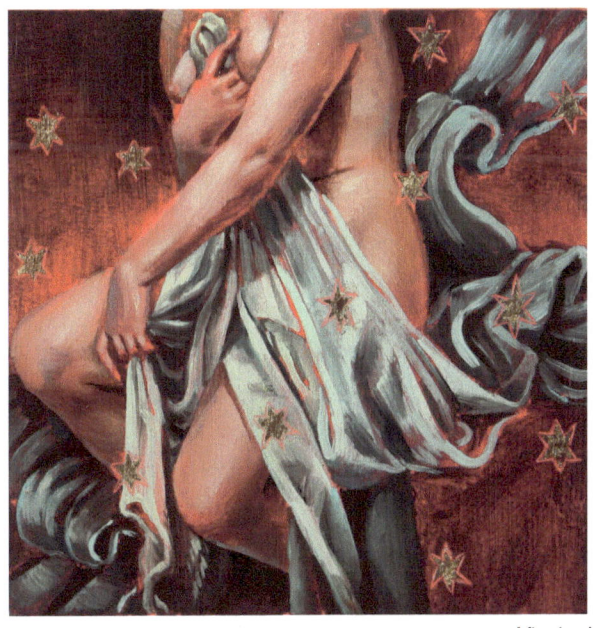

Virginal

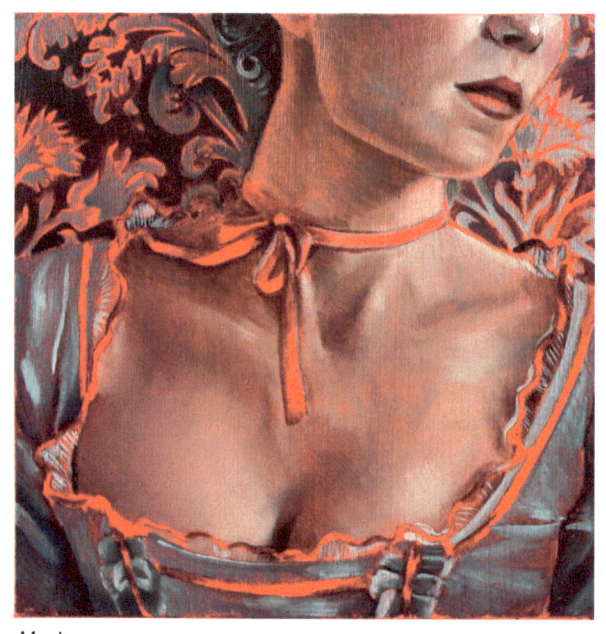

Marie

What would I reveal
if I could pull back
those ribs
Speak up, tell-tale heart

Internal downpour
I struggle to appear calm
when my heart is soaked

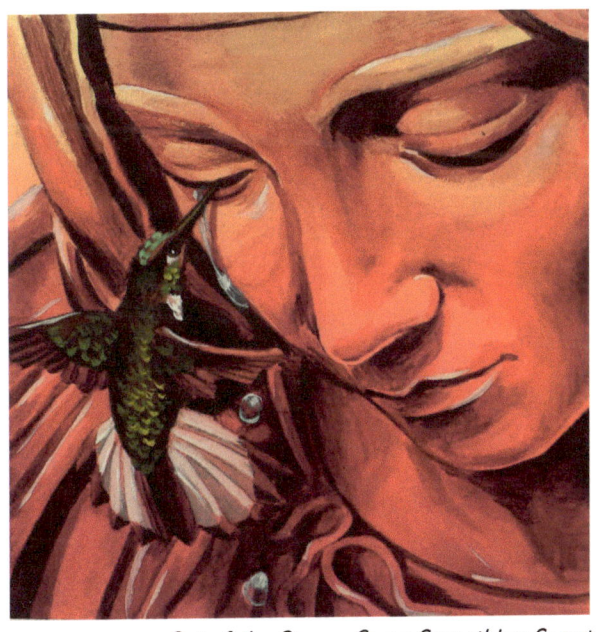

Out of the Strong Came Something Sweet

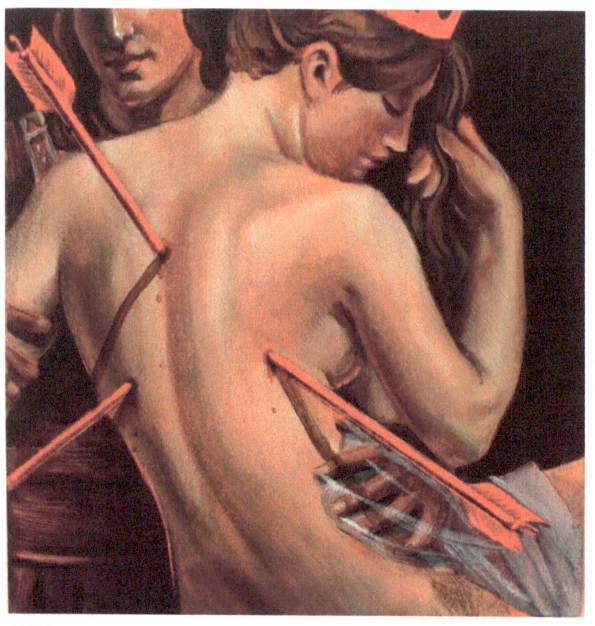

I Will Be Your Shield

A sweet addiction
that dangerous desire
brushing silk skin tones

Cure a sick flower
go back to corruption site
bloom purely from the heart

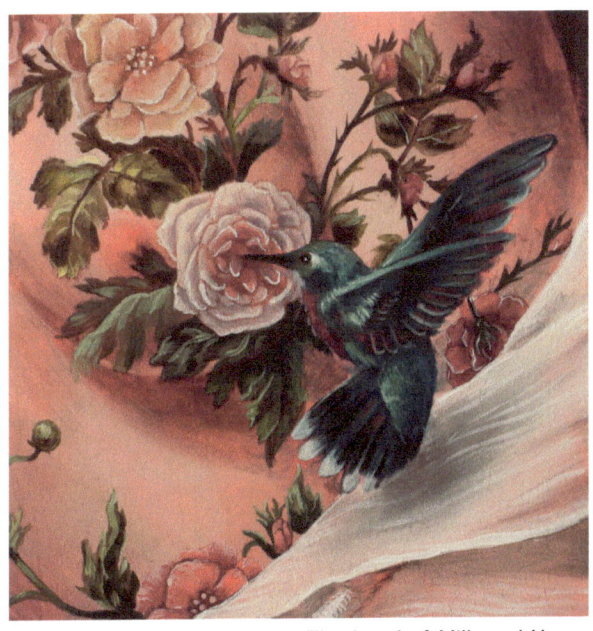

The Land of Milk and Honey

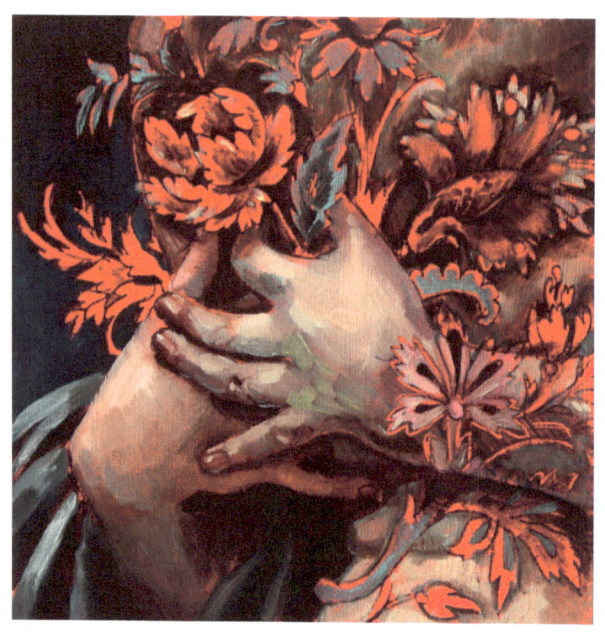

Boquet

Palms full of choices
though the future
　　is shrinking
it feels heavier

She reaps what
she sows
We've got a long
way to go
Patience like a stone

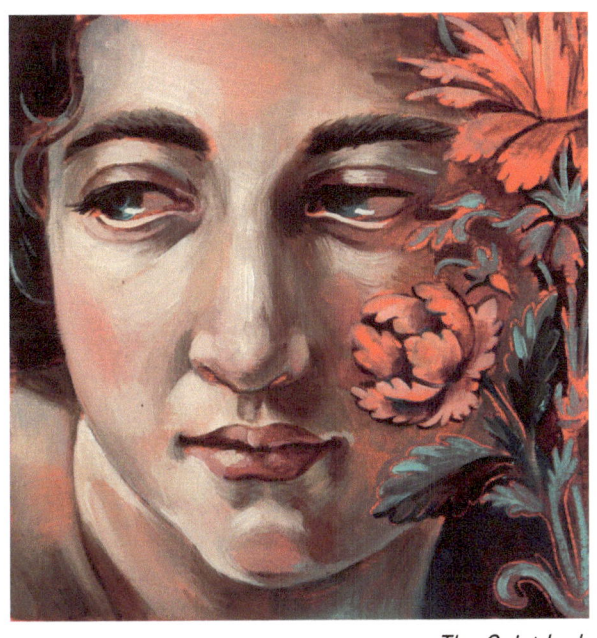

The Quiet Lady

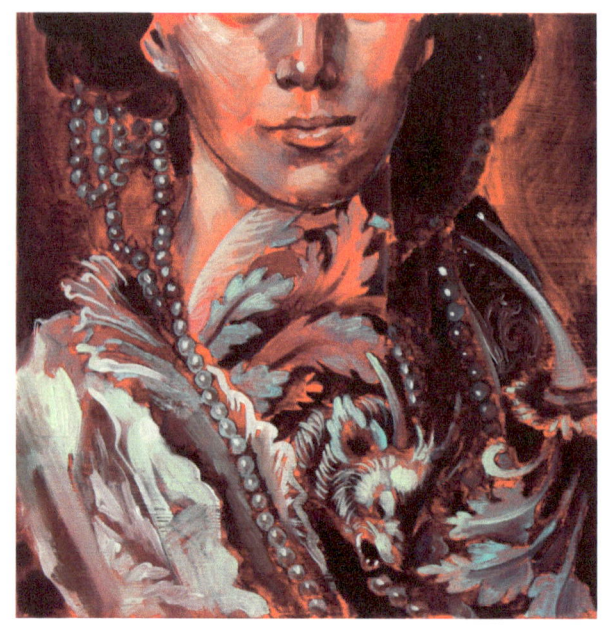

Upper Echelon

Regardless of strength
some wounds
remain within us
like sleeping dragons

He held my secrets
they sat heavy
 in his hands
but he didnt flinch

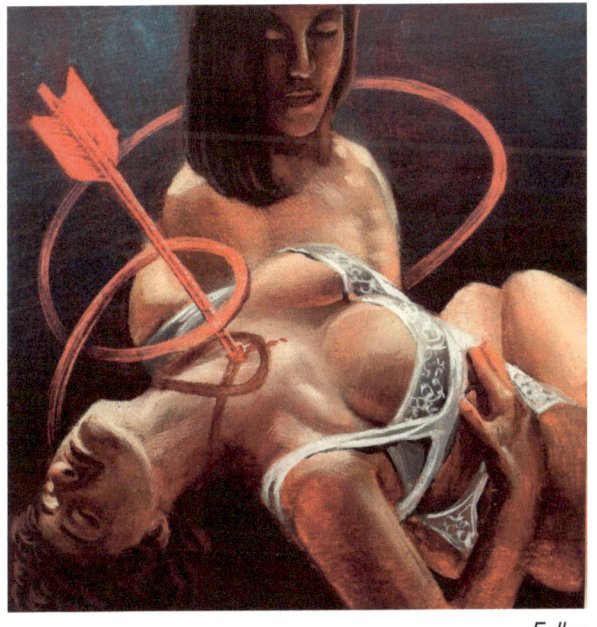

Fallen

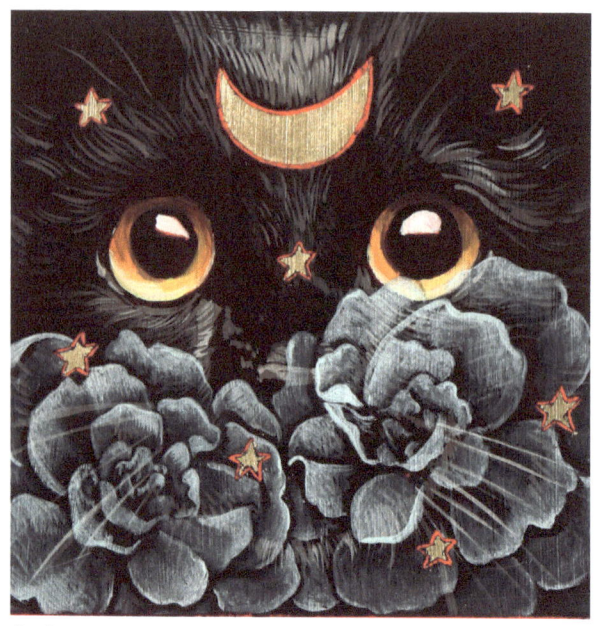

La Luna

In the witching hour
you'll find me
 crafting secrets
 in my dreamy mind

We were face to face
I let my heart float
 between us
and you breathed it in

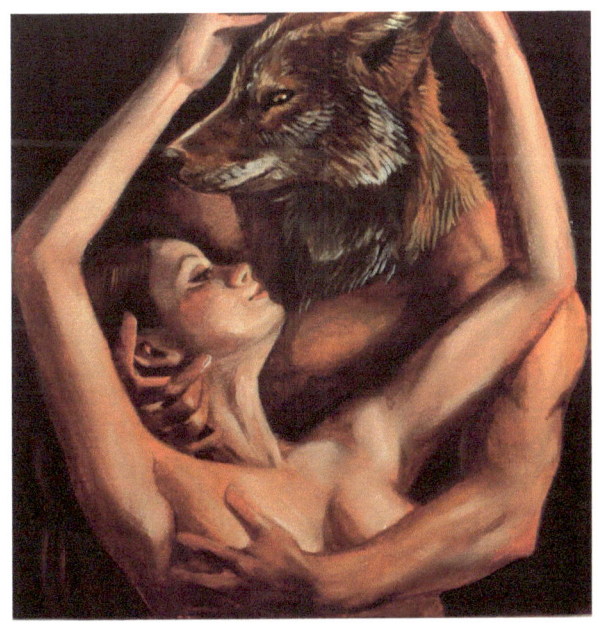

The Night I Fell in Love With a Coyote,
I Let Him Eat Me Piece by Piece

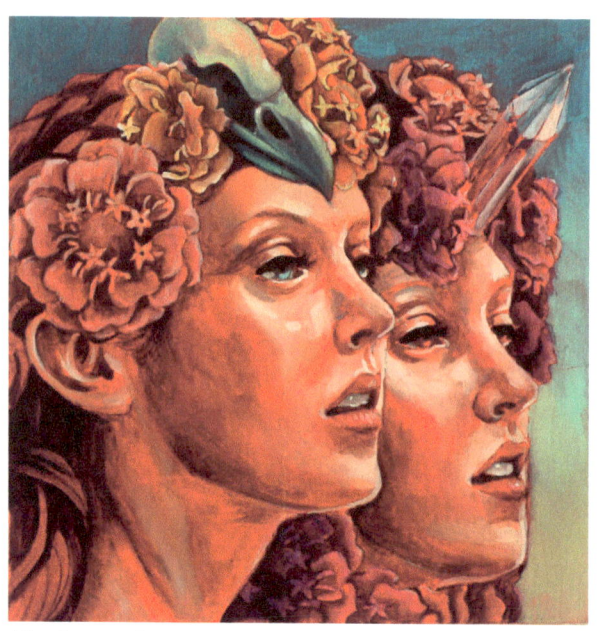

The Seeing Sisters Saw Our Future Together

In that brief moment
my future flashed
before me
I only saw you

I cannot fathom a parallel universe where our souls aren't mates

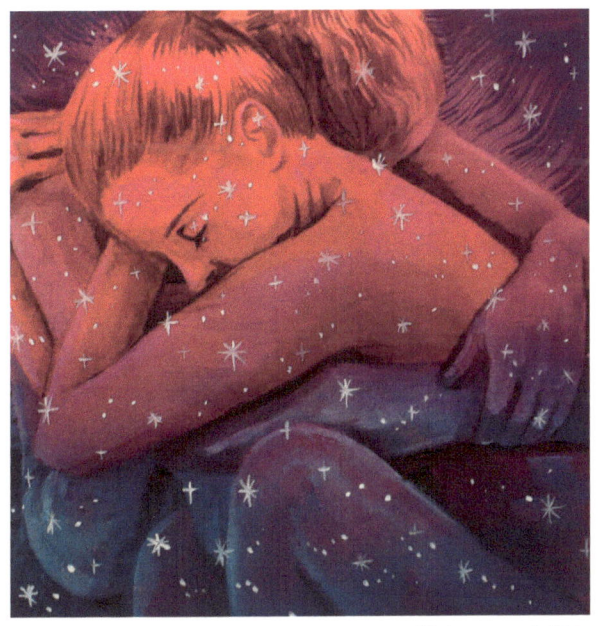

Universes Collide

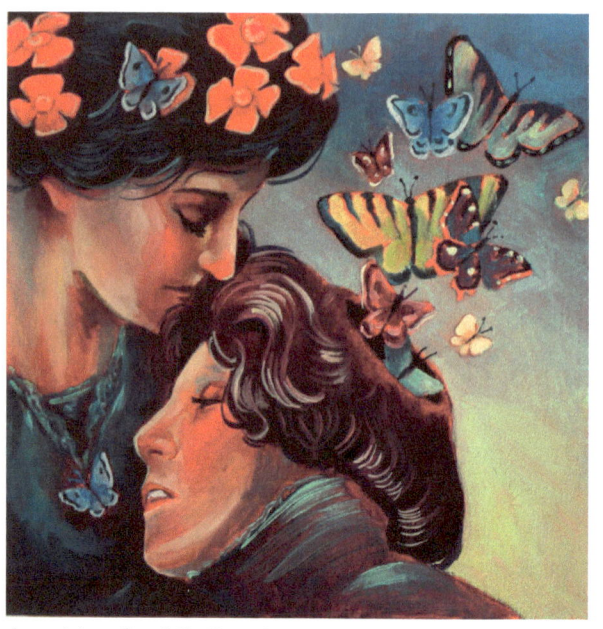

Imagining Our Life Together

that mythical place
where they keep
your fate locked up
is inside your mind

A chaotic mind overthinking everything yearning for stillness

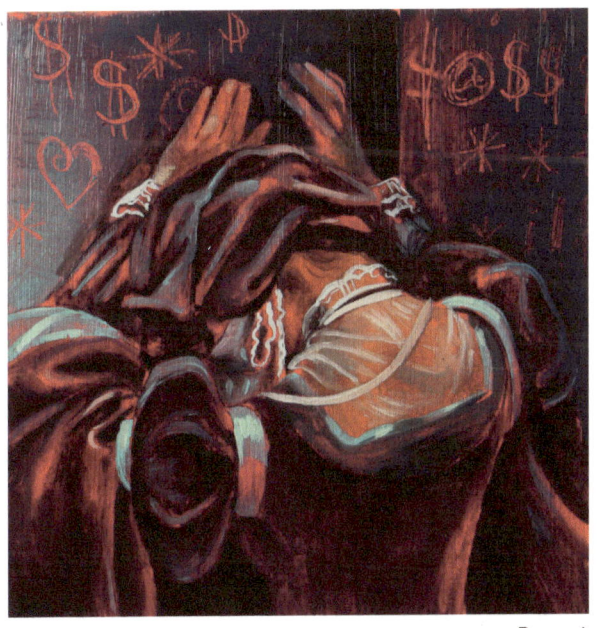

Despair

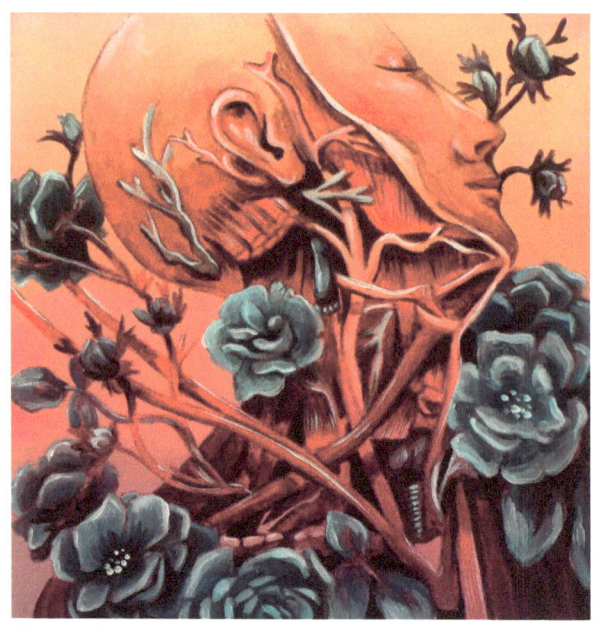

Sunset Bloom

Absorb the sunlight
let it melt into your skin
change with the season

*I sat pondering
I feasted on
whys and hows
until I felt sick*

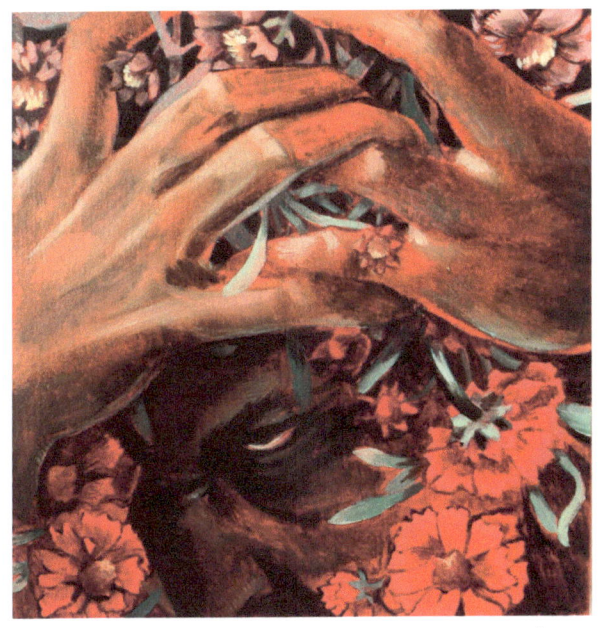

Agony

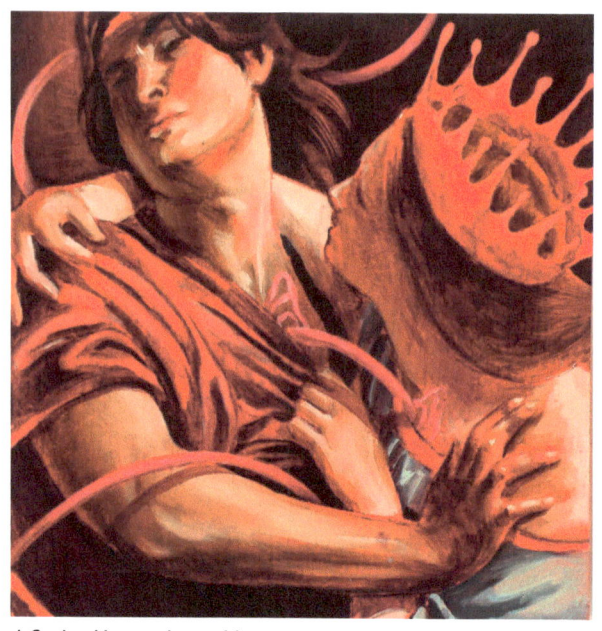

I Order You to Love Me

Chink in the armor
choose a weapon
and take aim
until you draw blood

Wonderful flashbacks
those silent
slow motion smiles
inspiring new ones

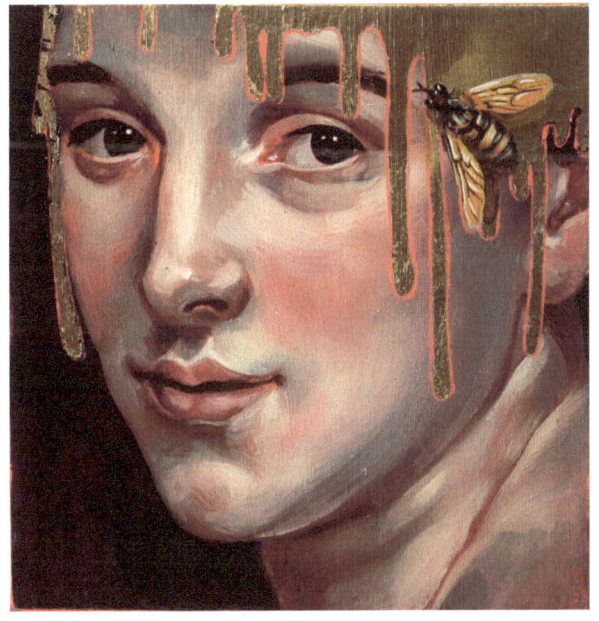

Honey, Honey, Food for the Bees

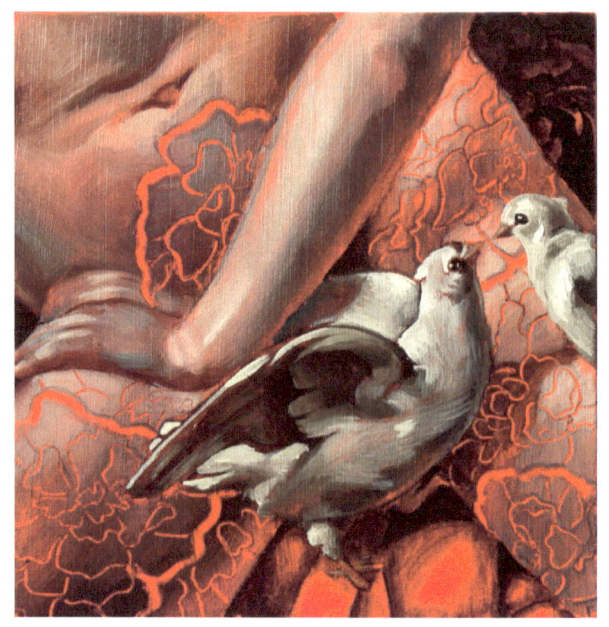

Dove Lovers

Change is upon us
flowers and life
in full bloom
crescendo to bliss

*If we are alive
our destiny is
disguised
maybe we're asleep*

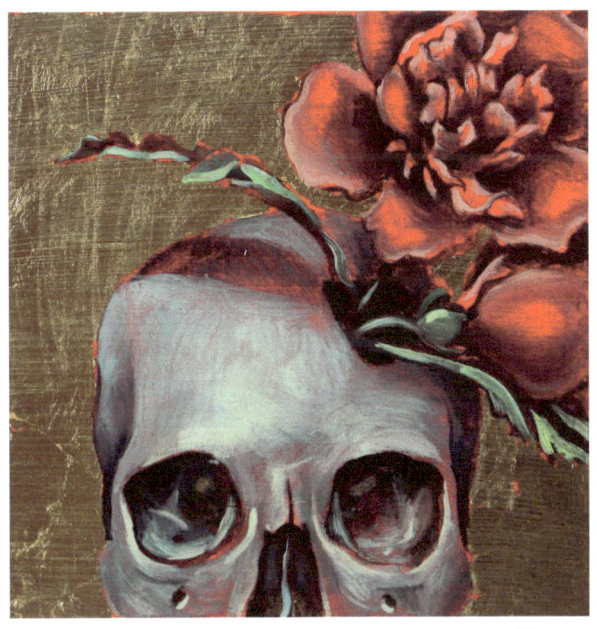

Nirvana

ALISE SECOR lives in Minneapolis with three roommates and a little feline friend. When she's sleeping, she dreams of roundhouse kicking bad guys, being naked in public, and getting sorted into Ravenclaw. When she's awake, she dreams of writing a novel, seeing the world, and mastering spaghetti carbonara. Currently, Alise is training to become a flight attendant and probably can't find her keys.
Follow her on instagram: @alisenoel and @haikunamatataa

ANDREA GUZZETTA is a Milwaukee artist who paints with hot pink and also dabbles in stained glass, stand-up comedy, and aerial yoga. She enjoys learning new things and talking about feelings. Her greatest joys include sunrises, being mistaken for Luna Lovegood and petting her tiny dog.
Check out her work at: www.aguzze.com
Follow her on Instagram @andreaguzzetta

www.ingramcontent.com/pod-product-compliance
Lightning Source LLC
Chambersburg PA
CBHW040926180526
45159CB00002BA/622